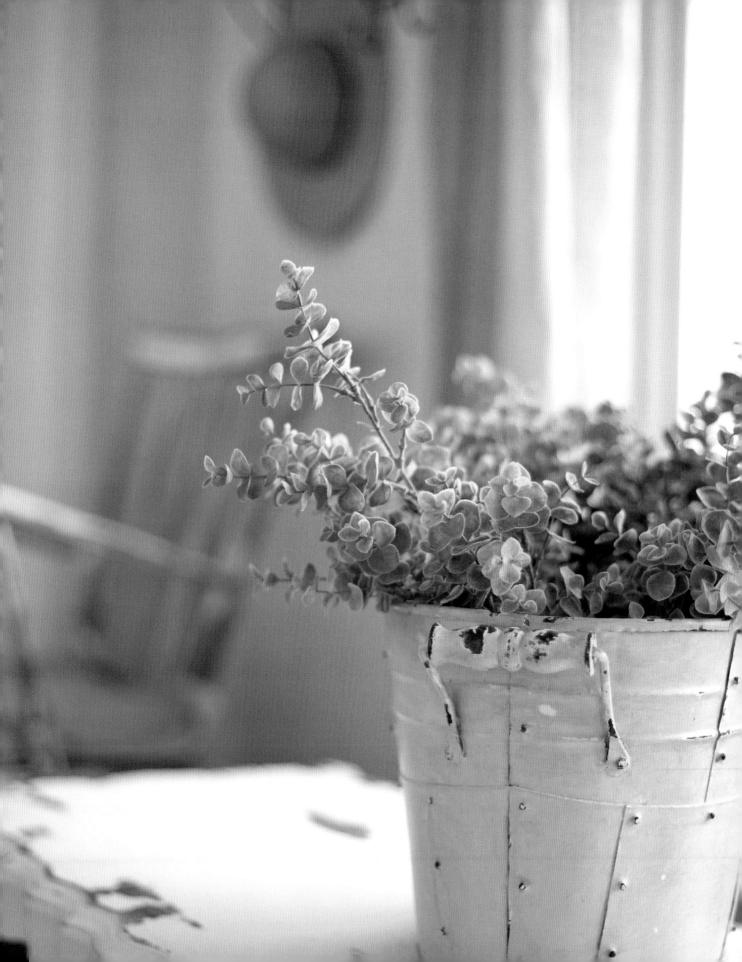

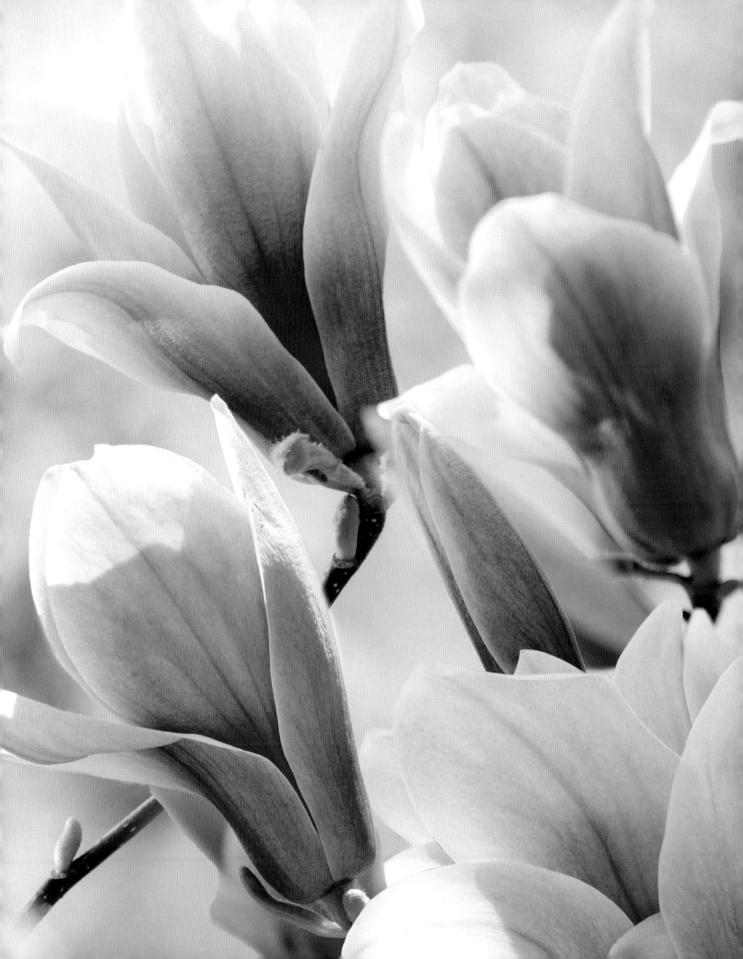

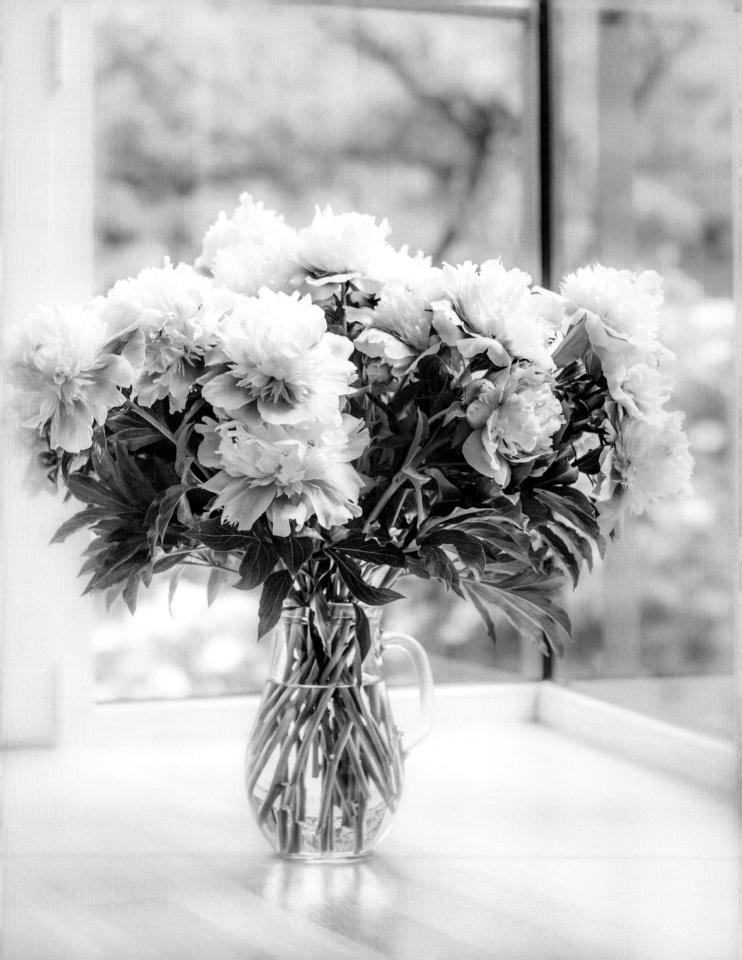

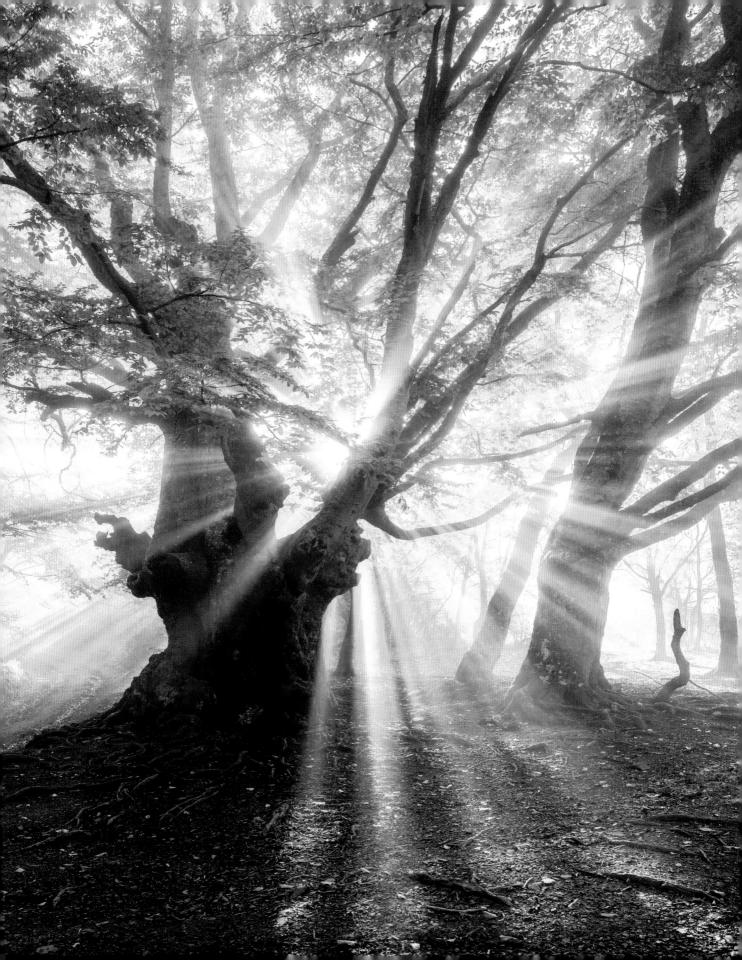

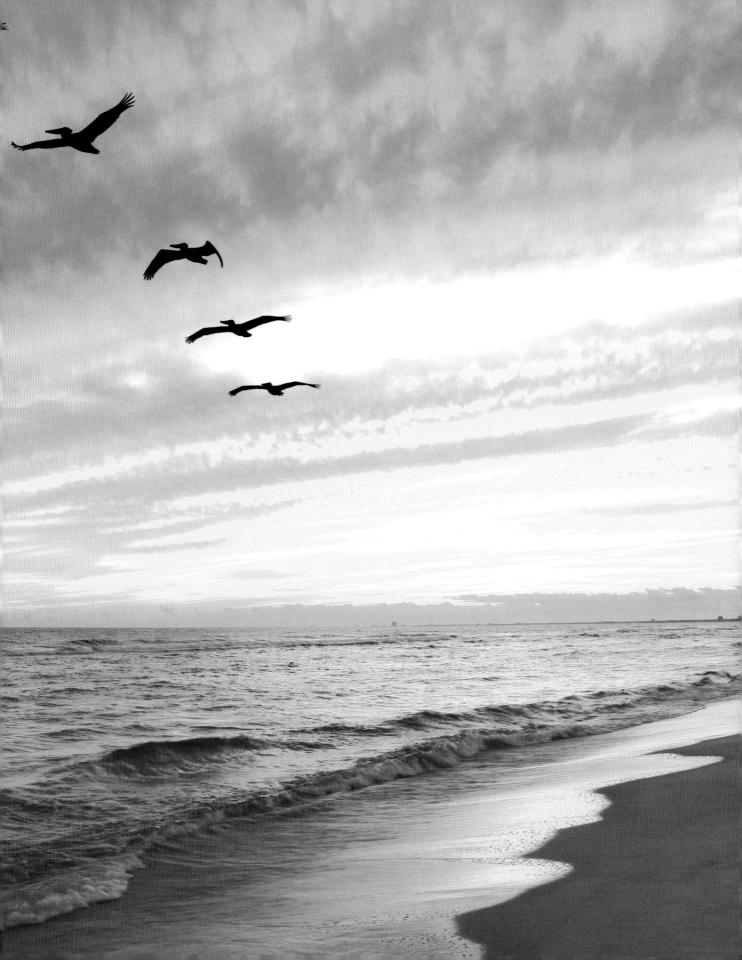

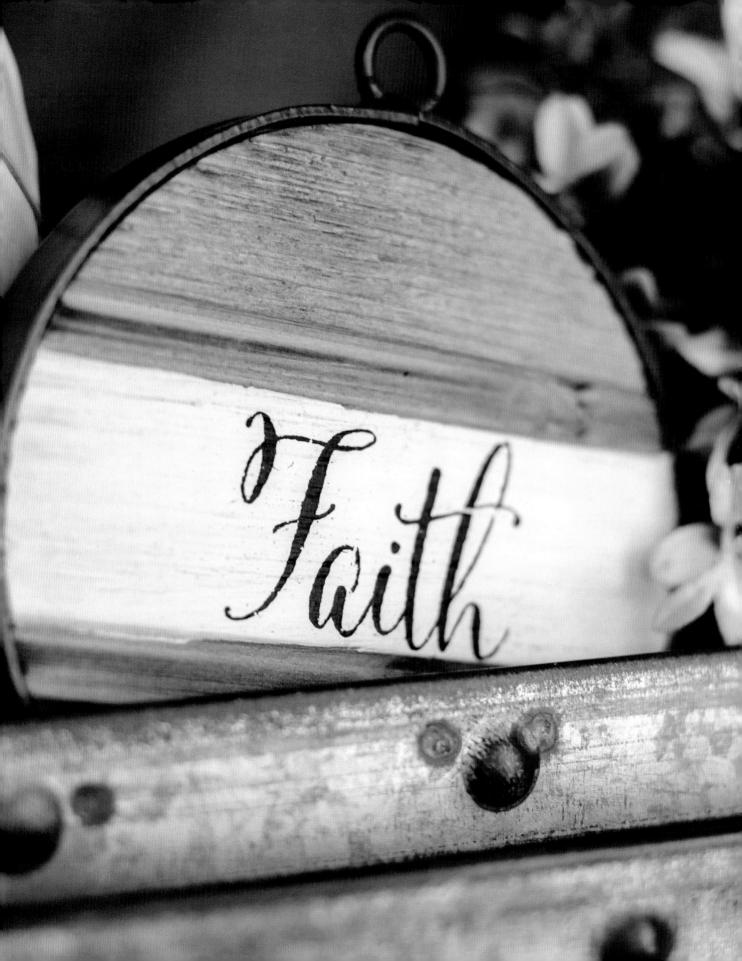

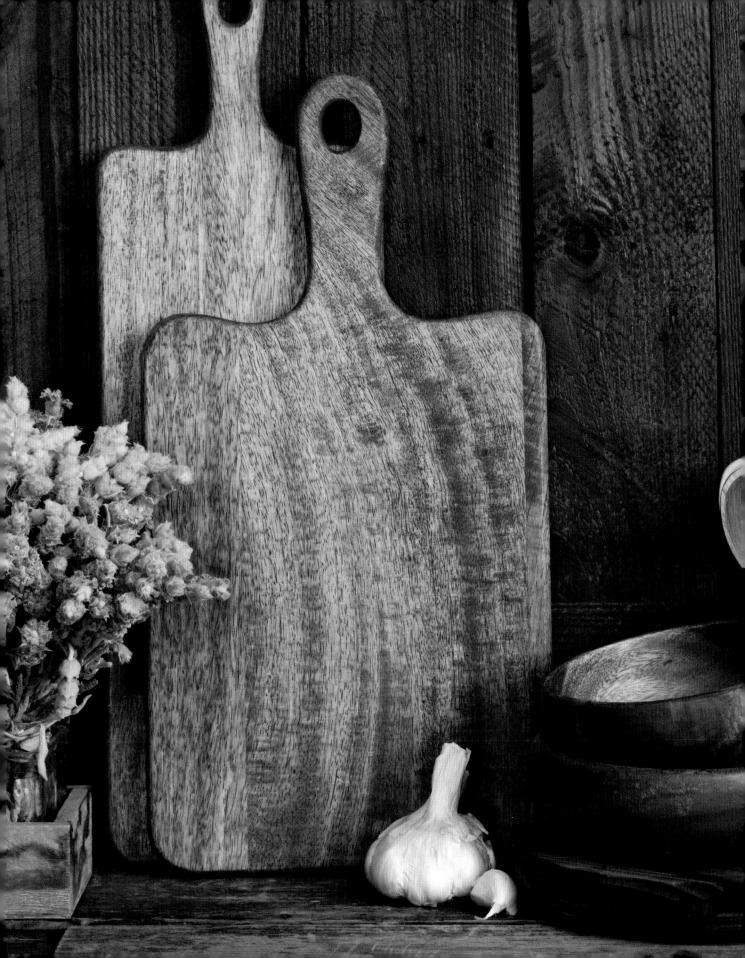

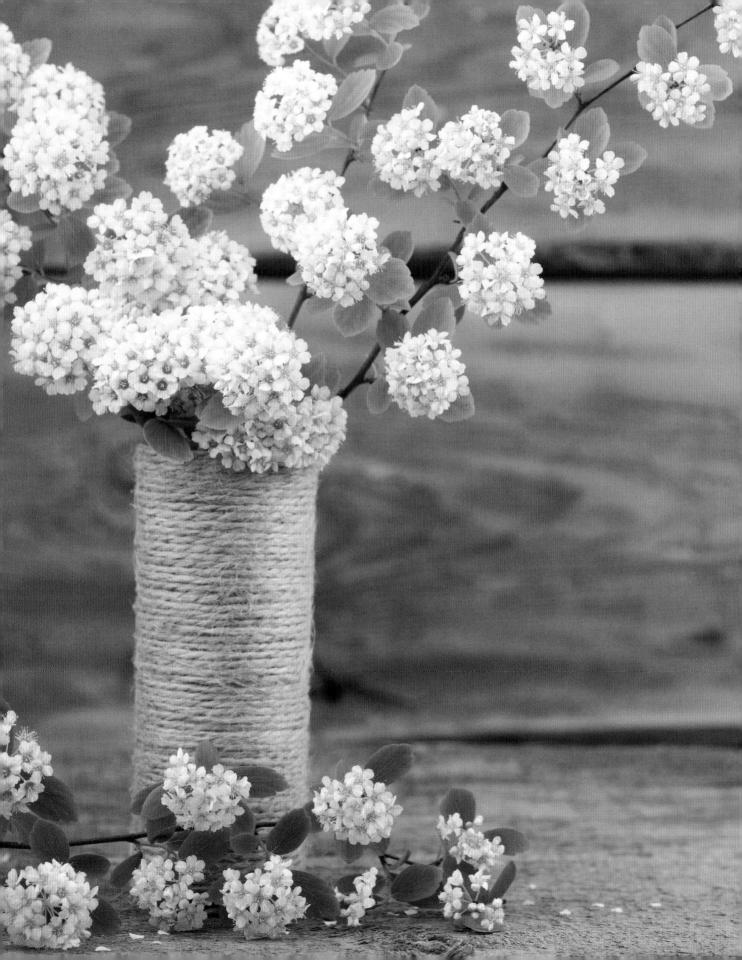

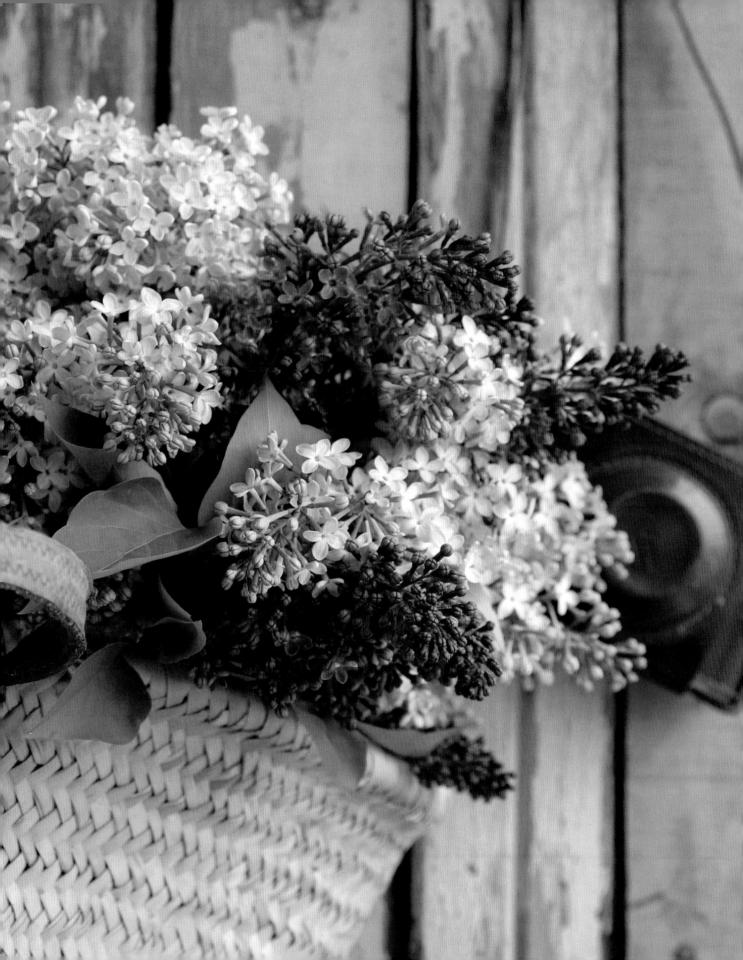

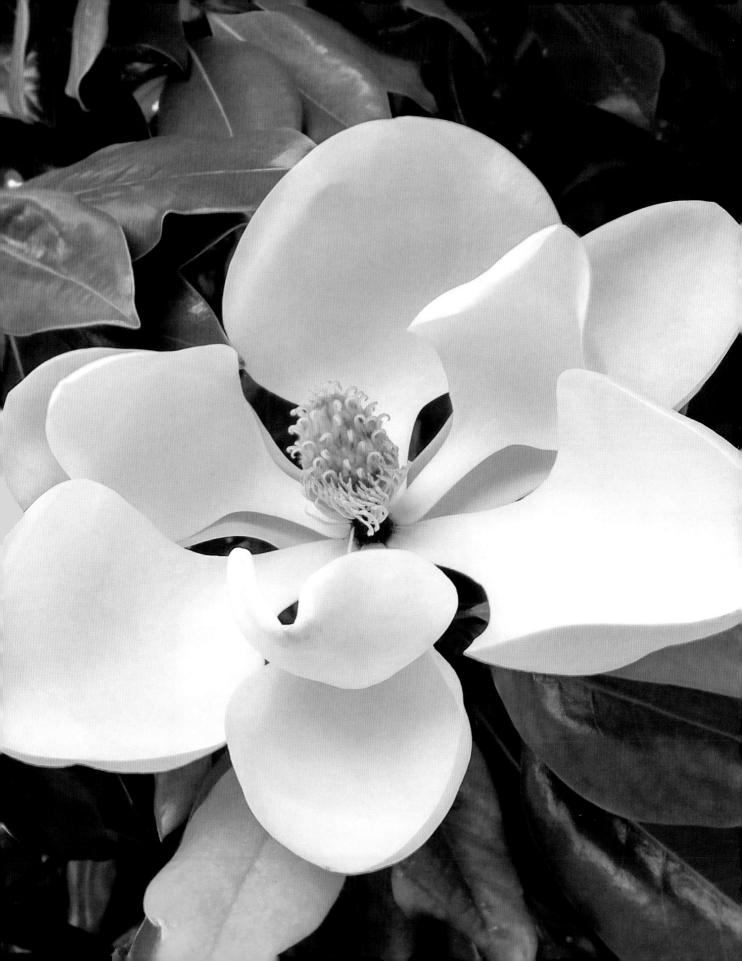

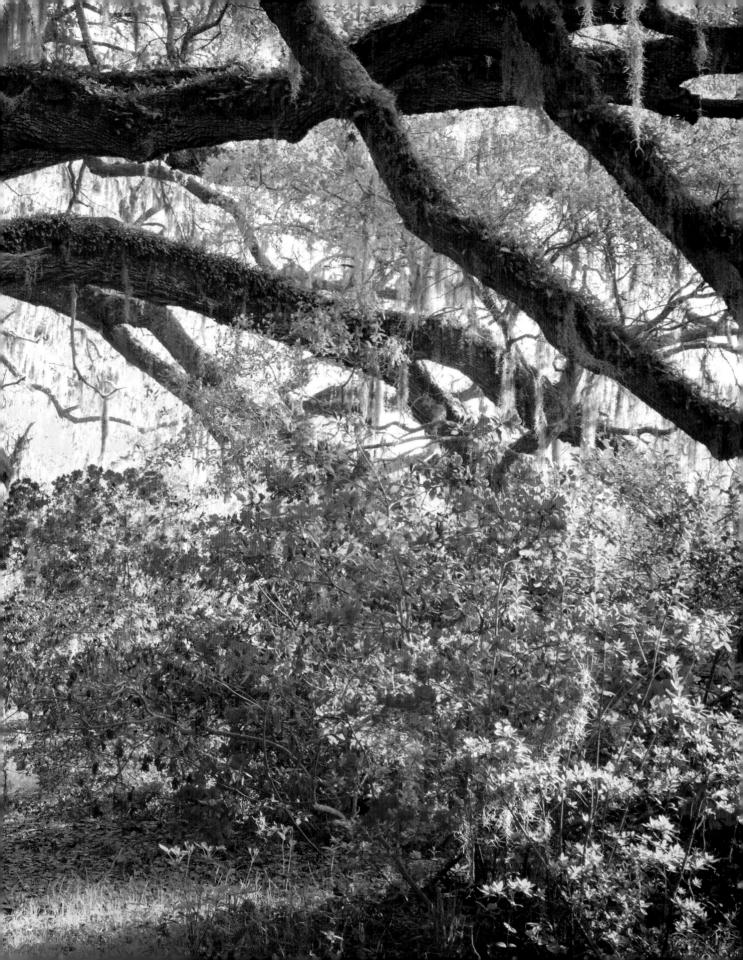

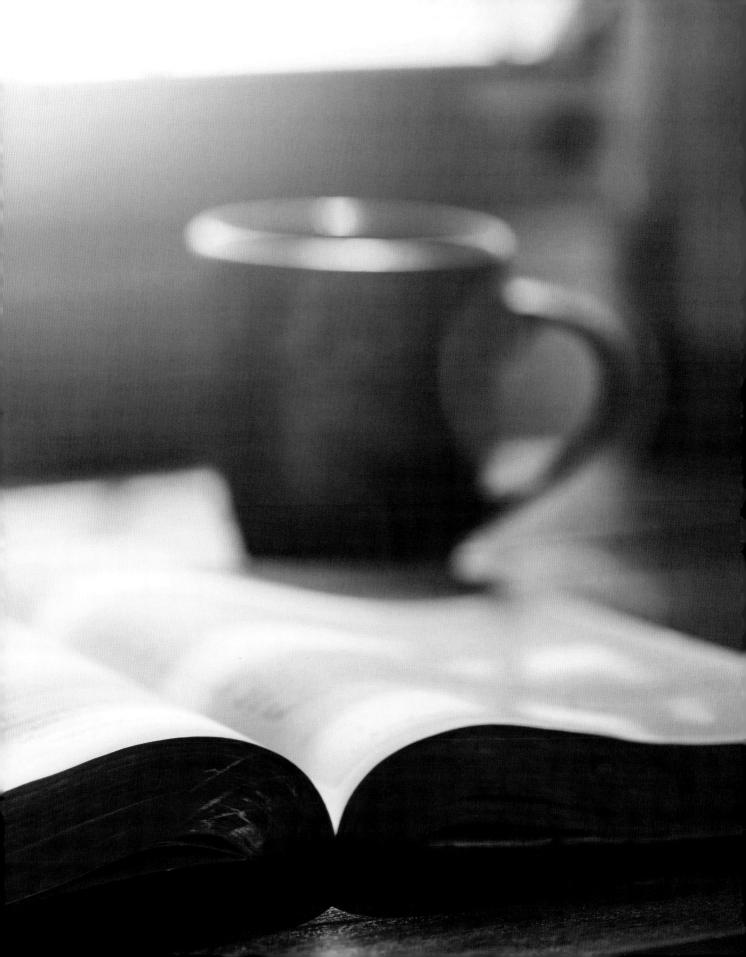

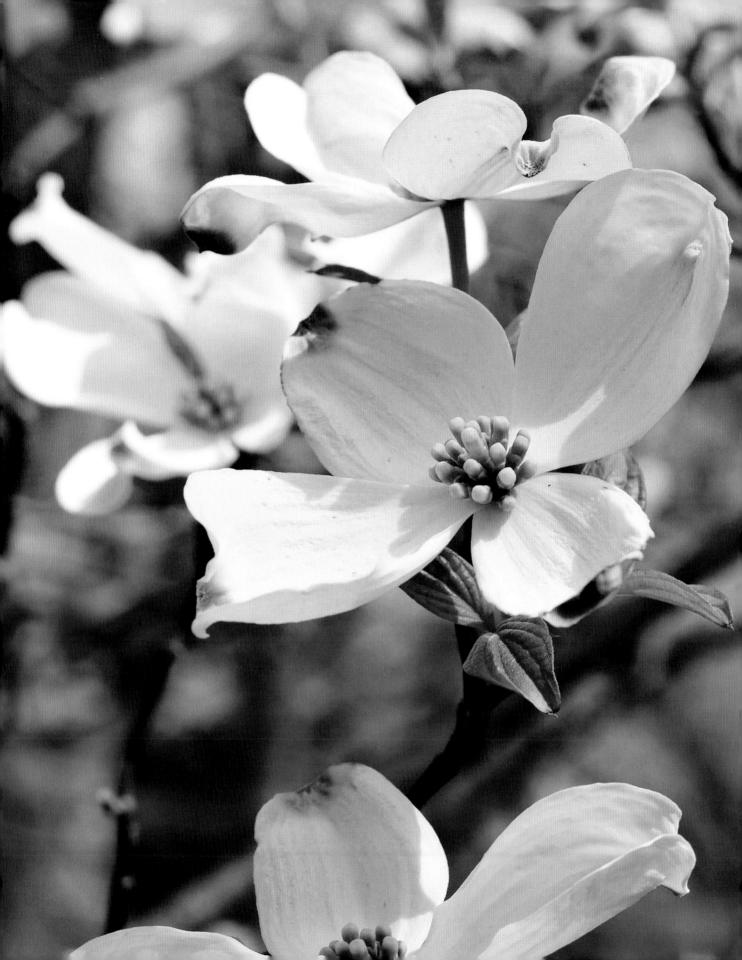

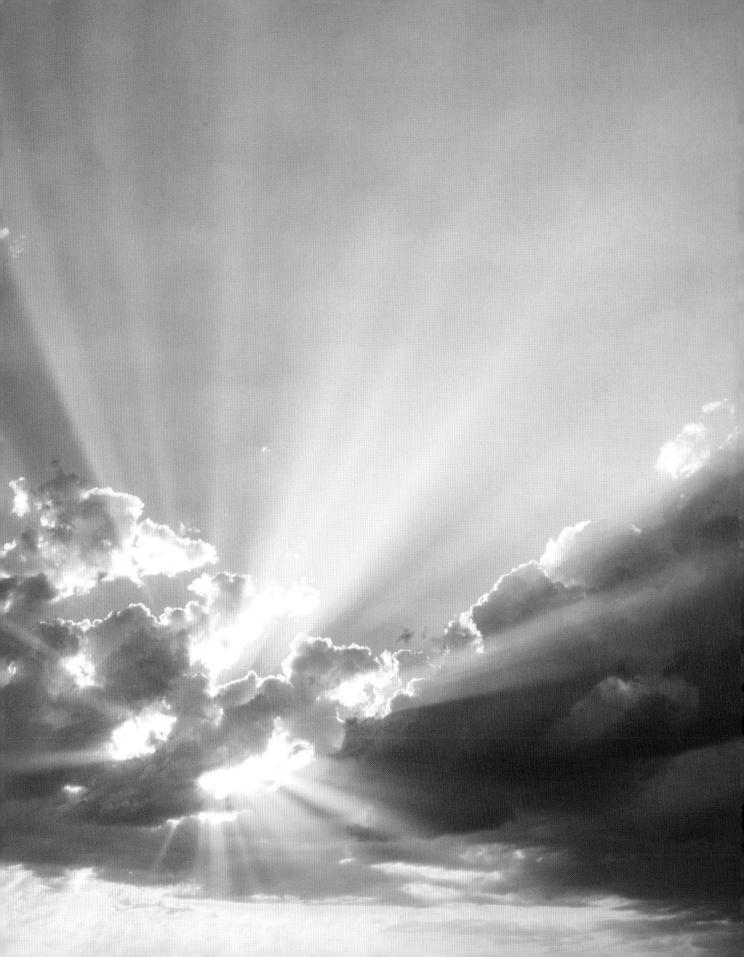

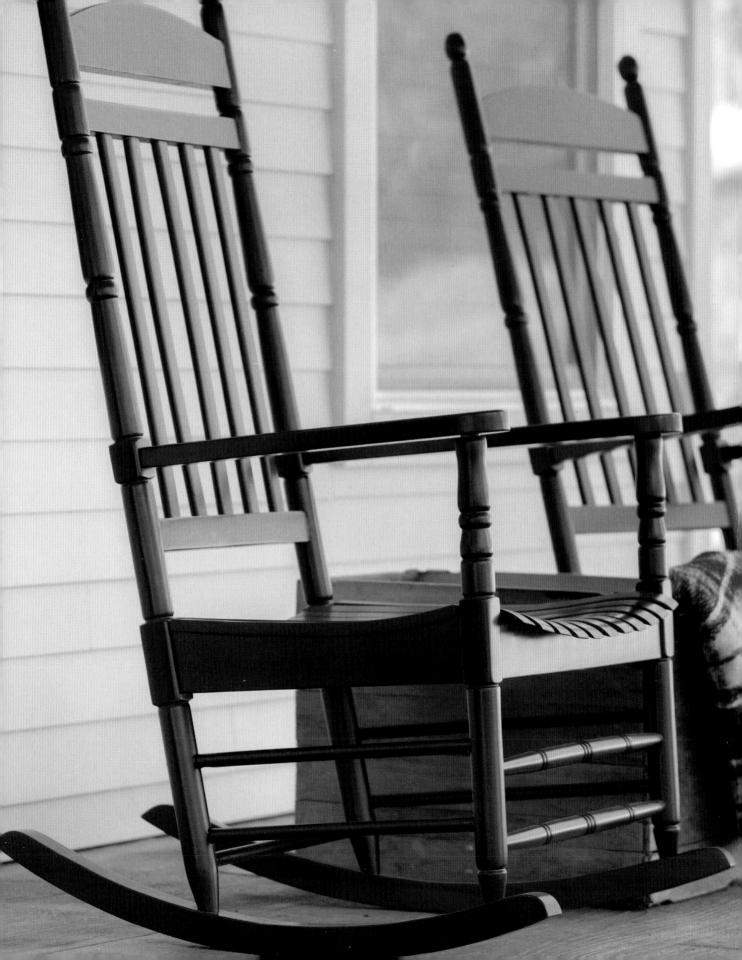

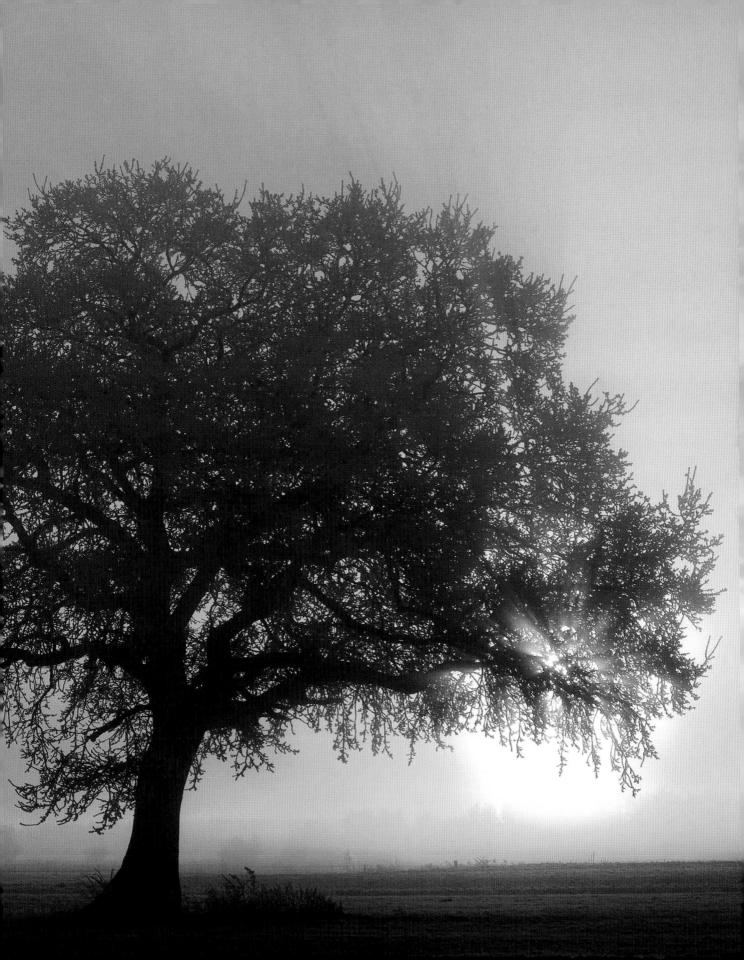

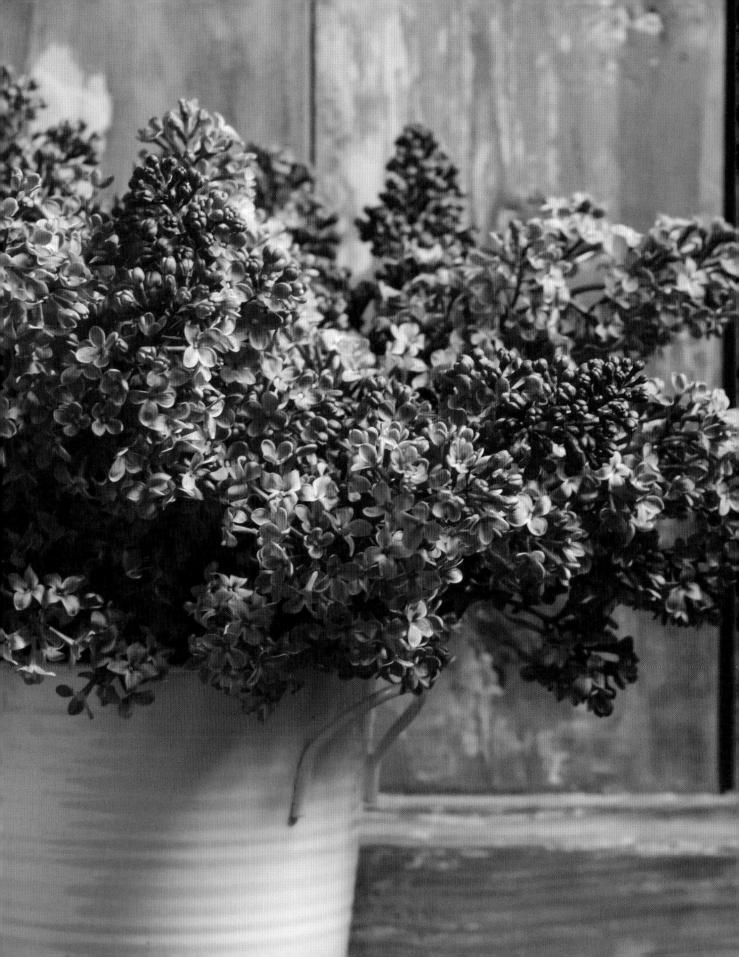

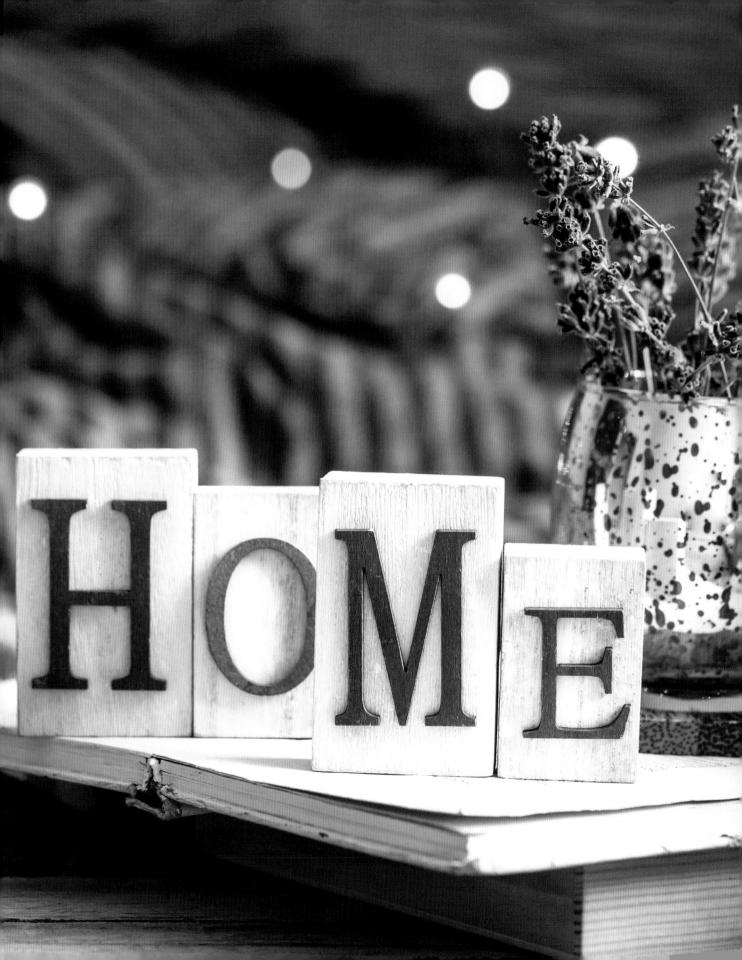

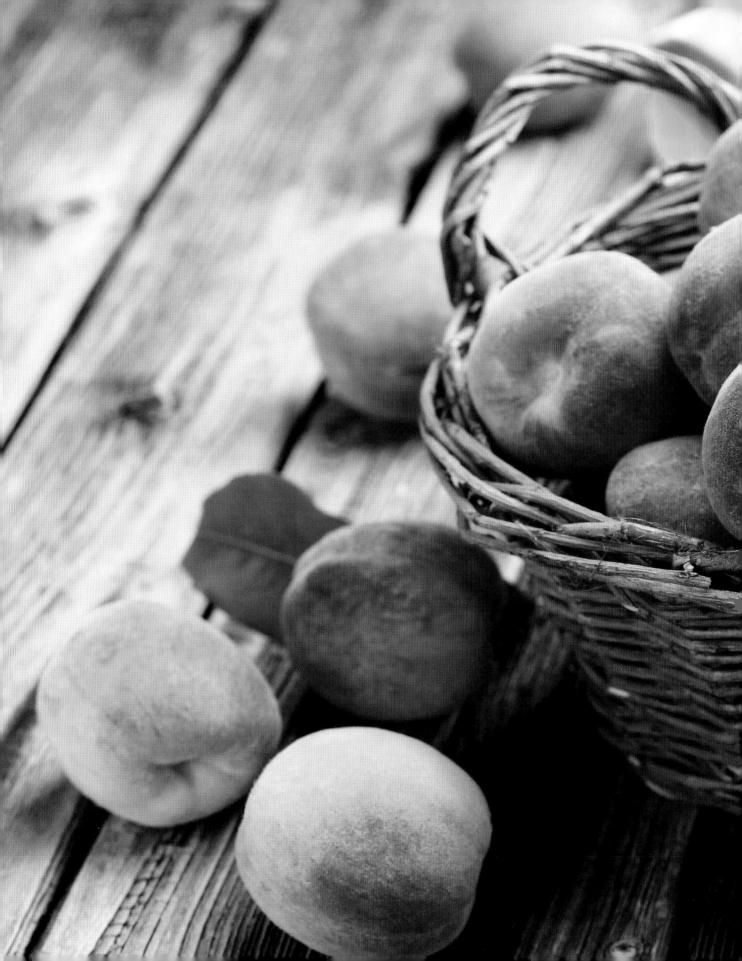

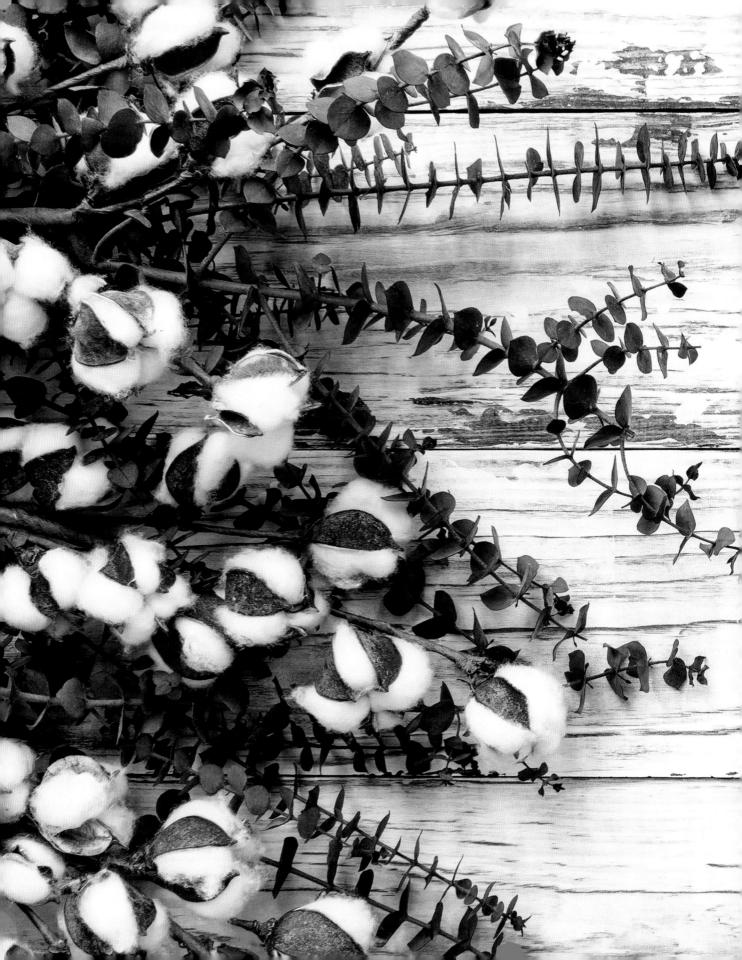

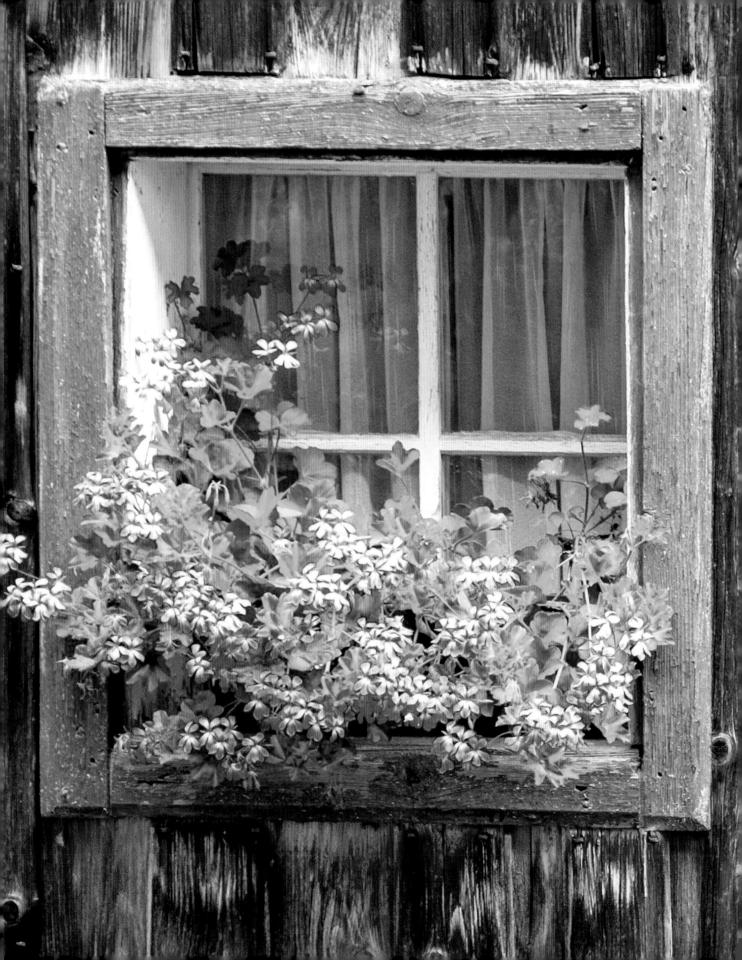

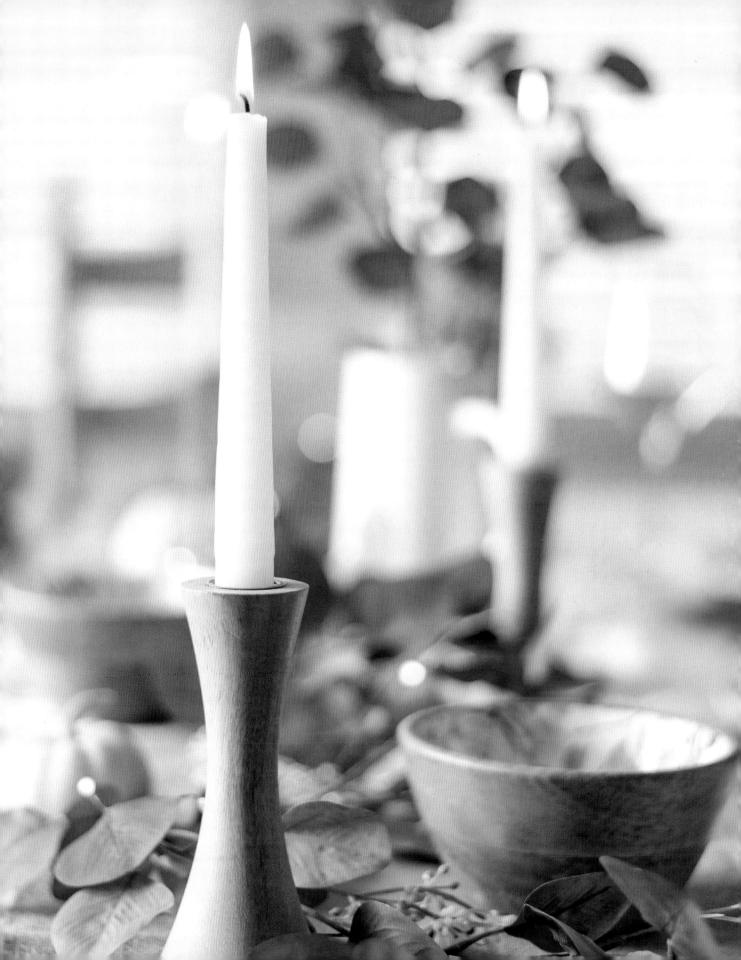

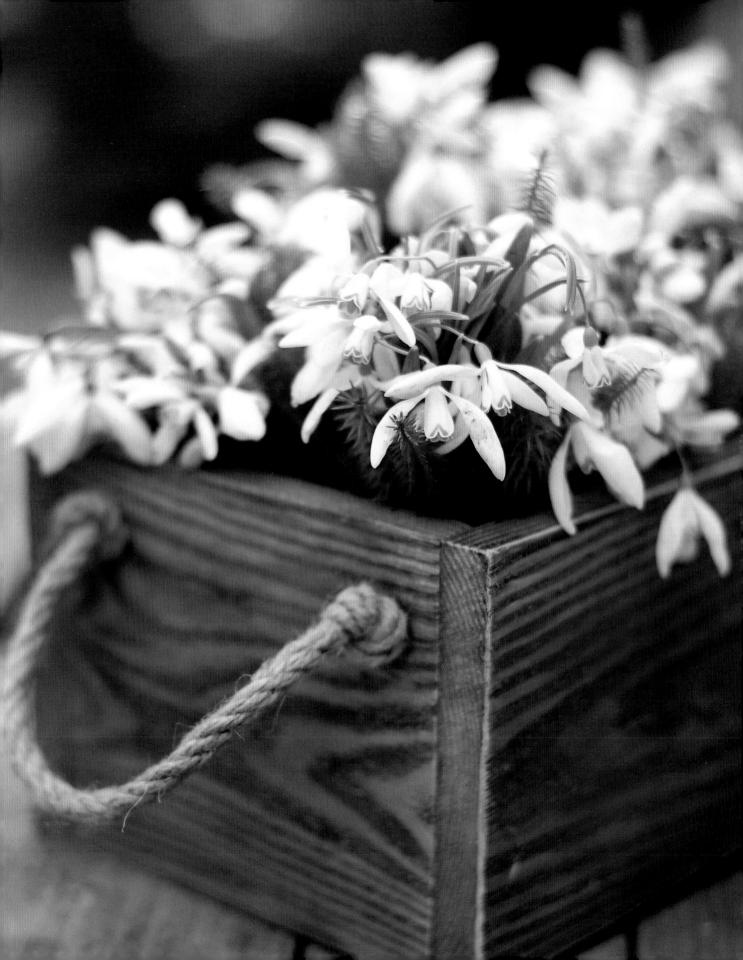

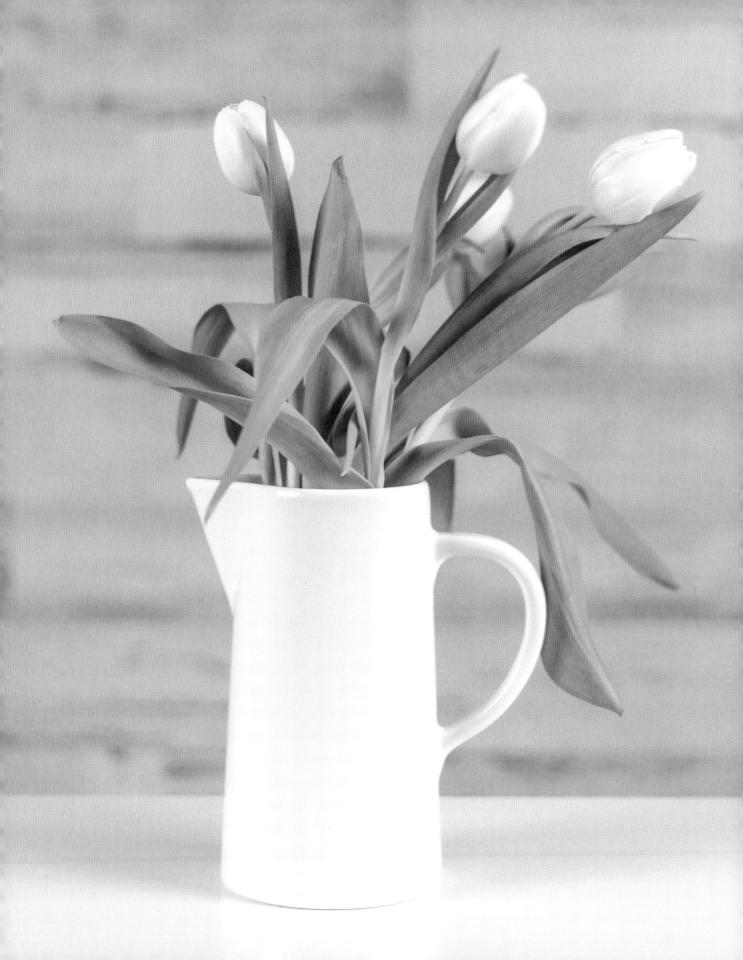

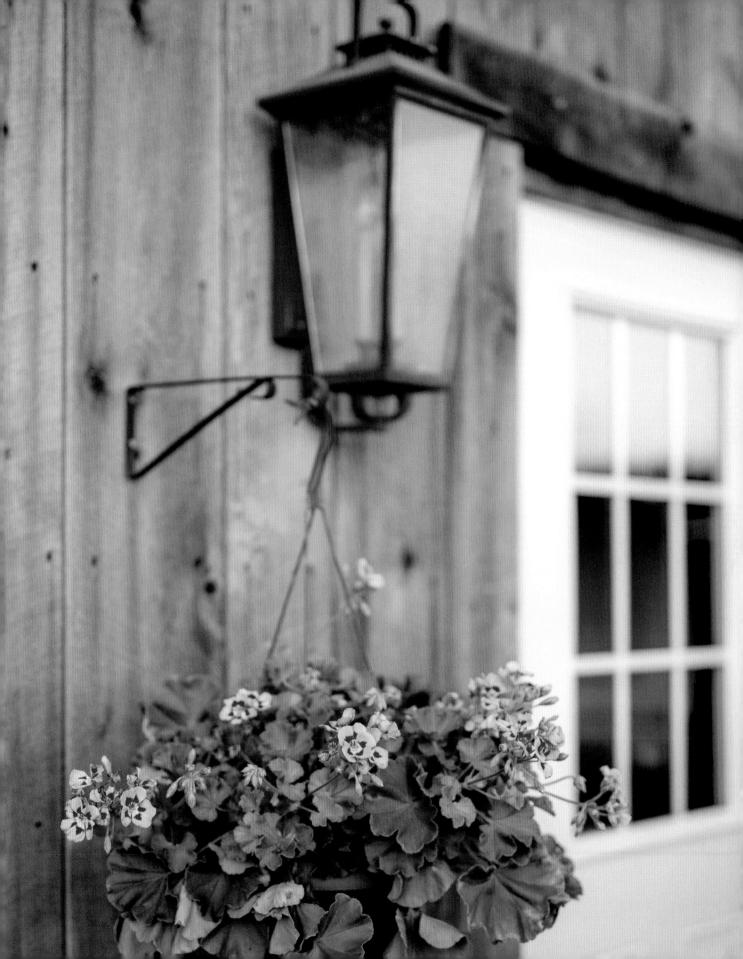

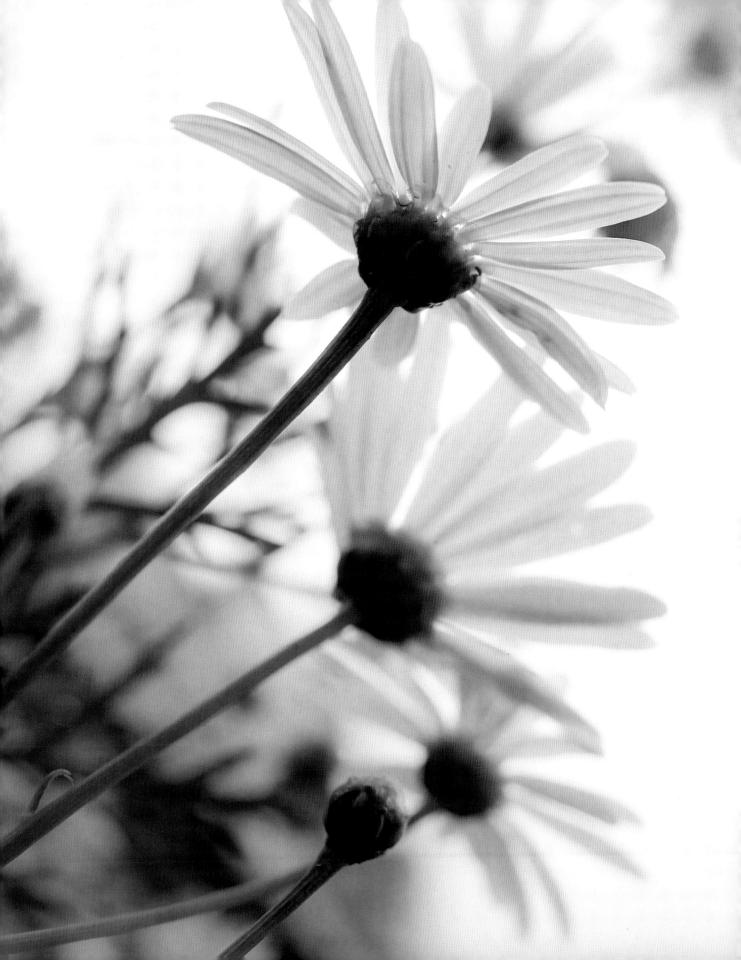

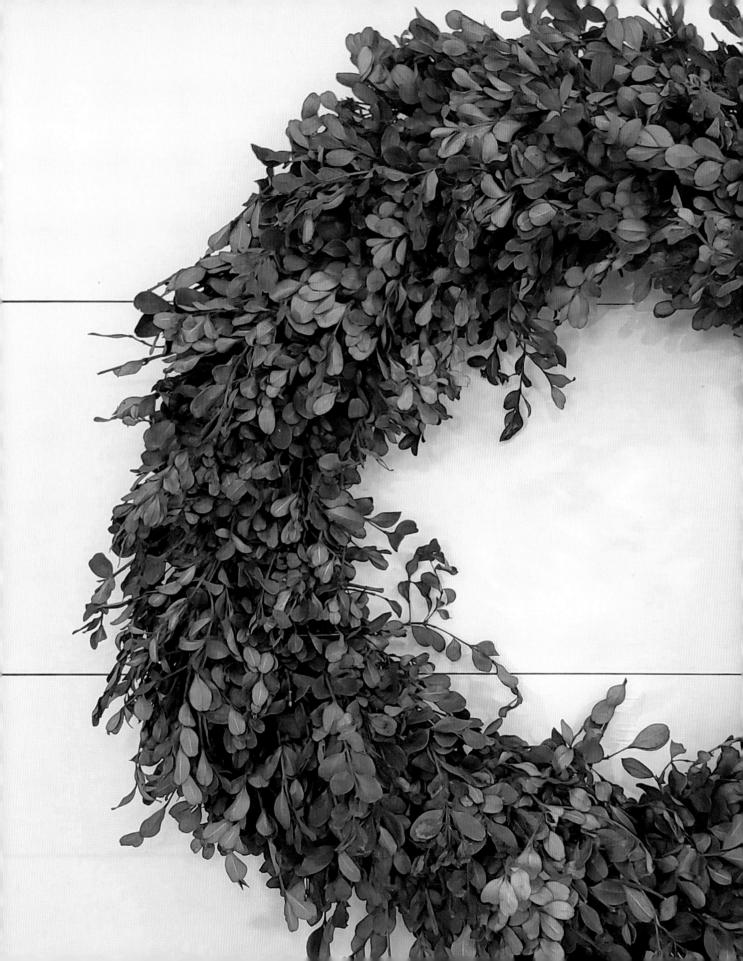

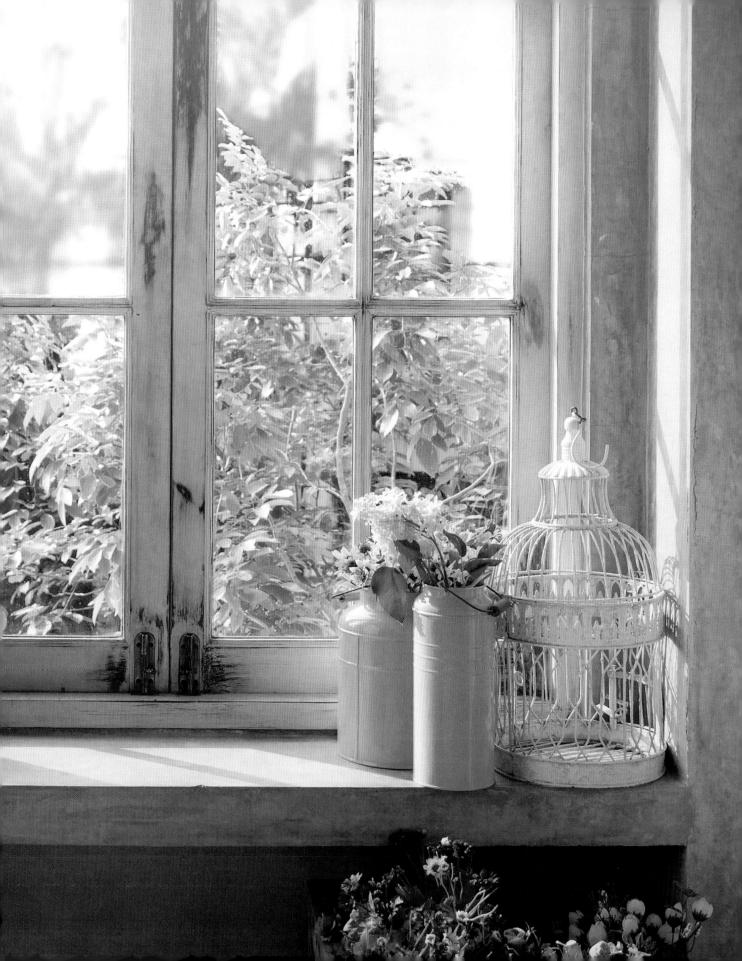

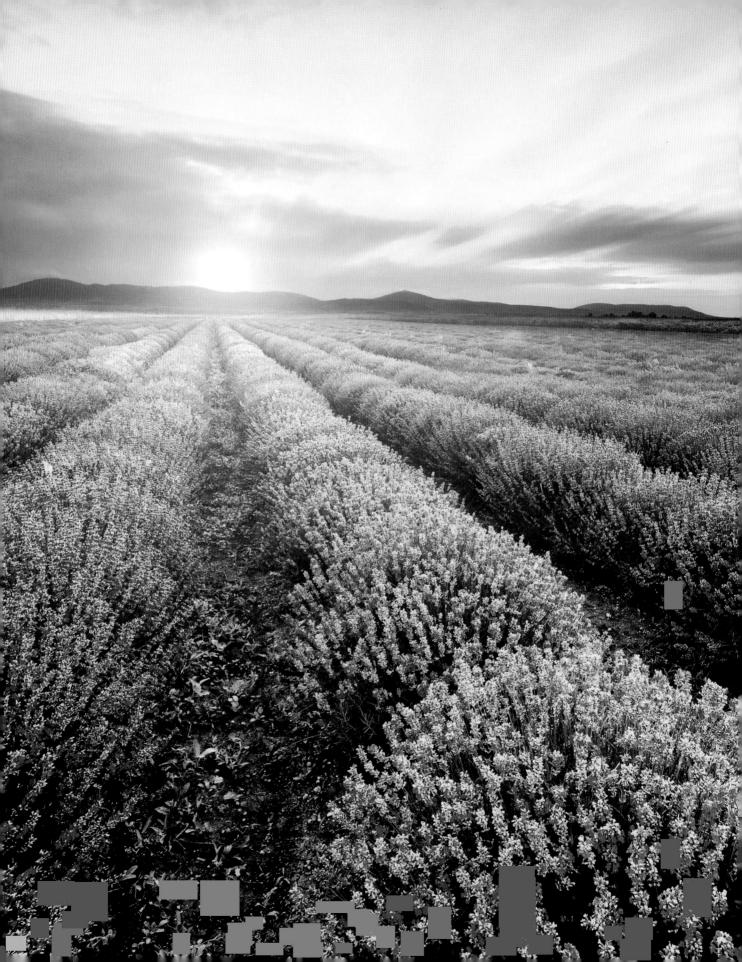

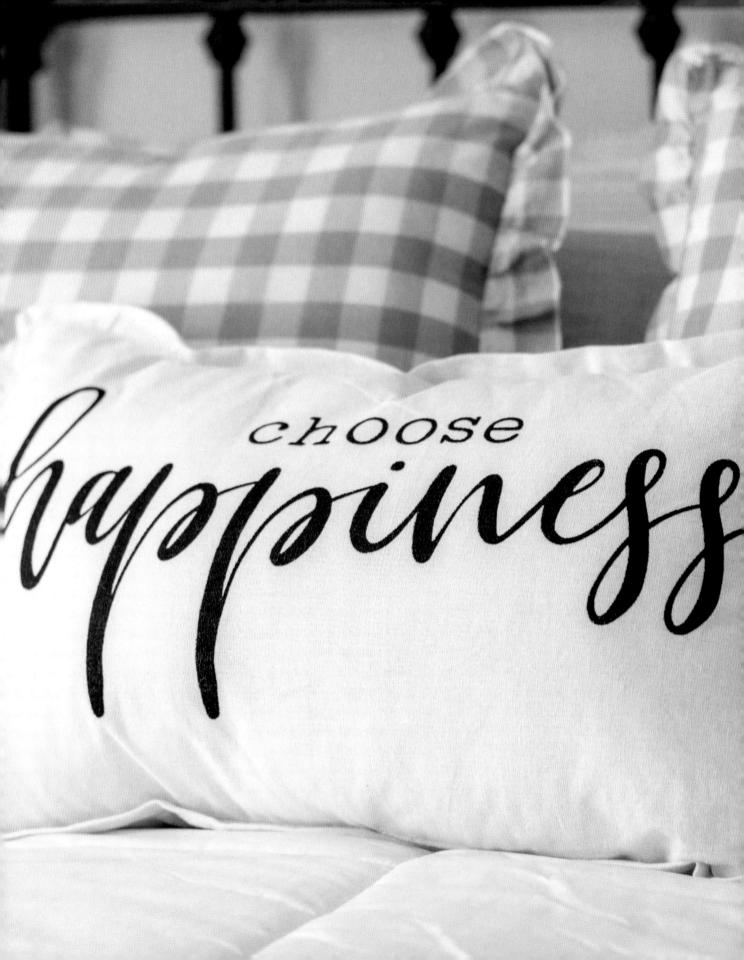

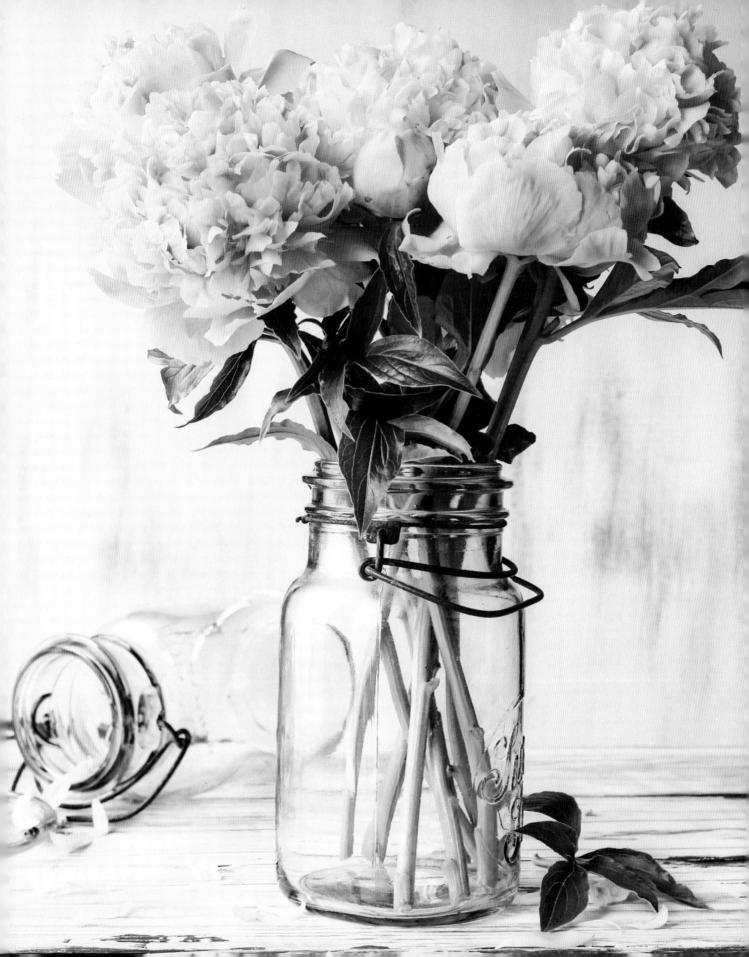

The OUP Family is life's greatest Blessing

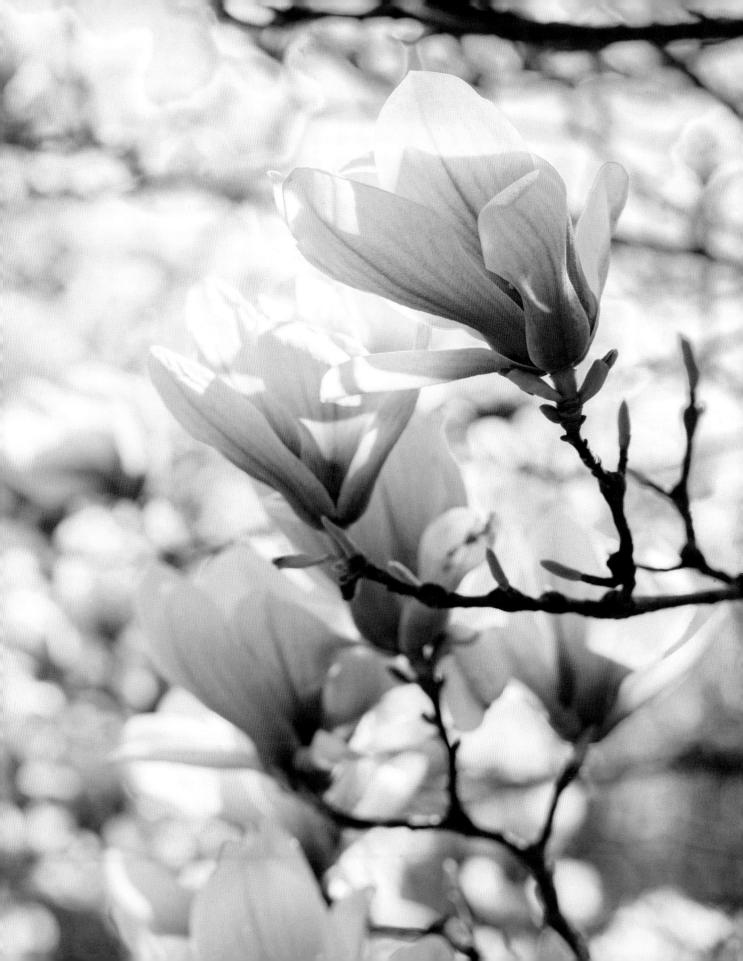

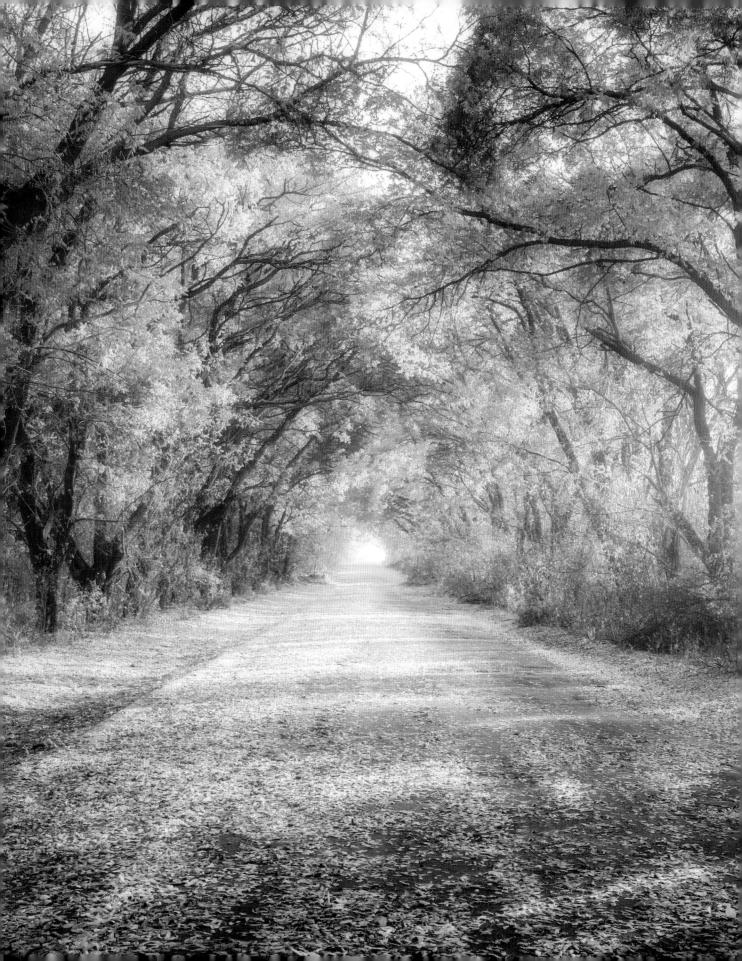

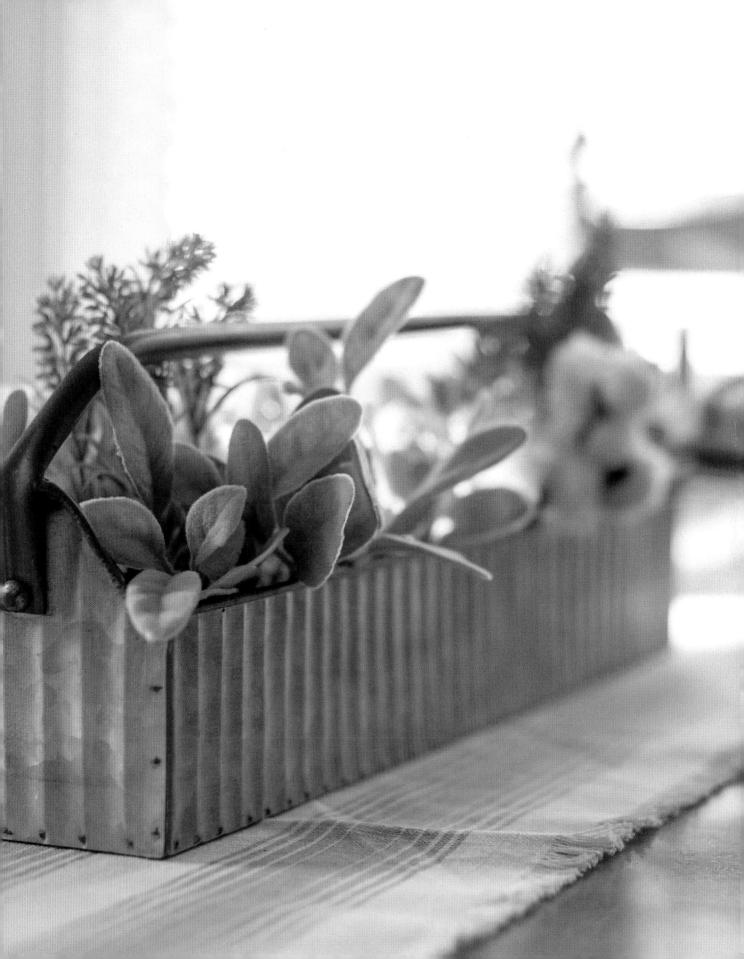

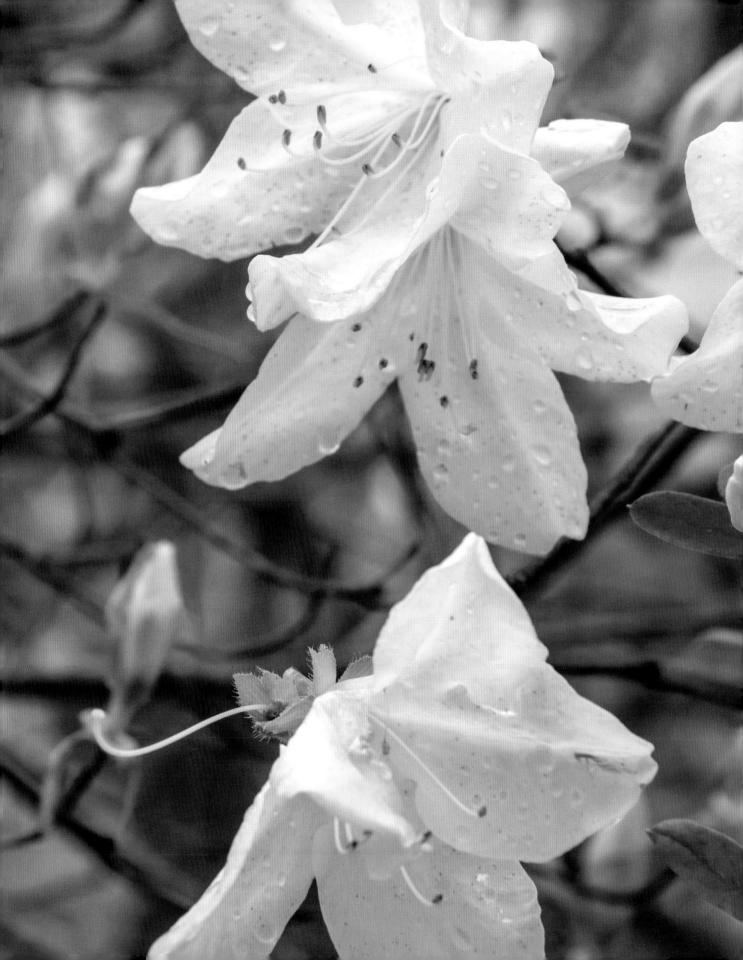

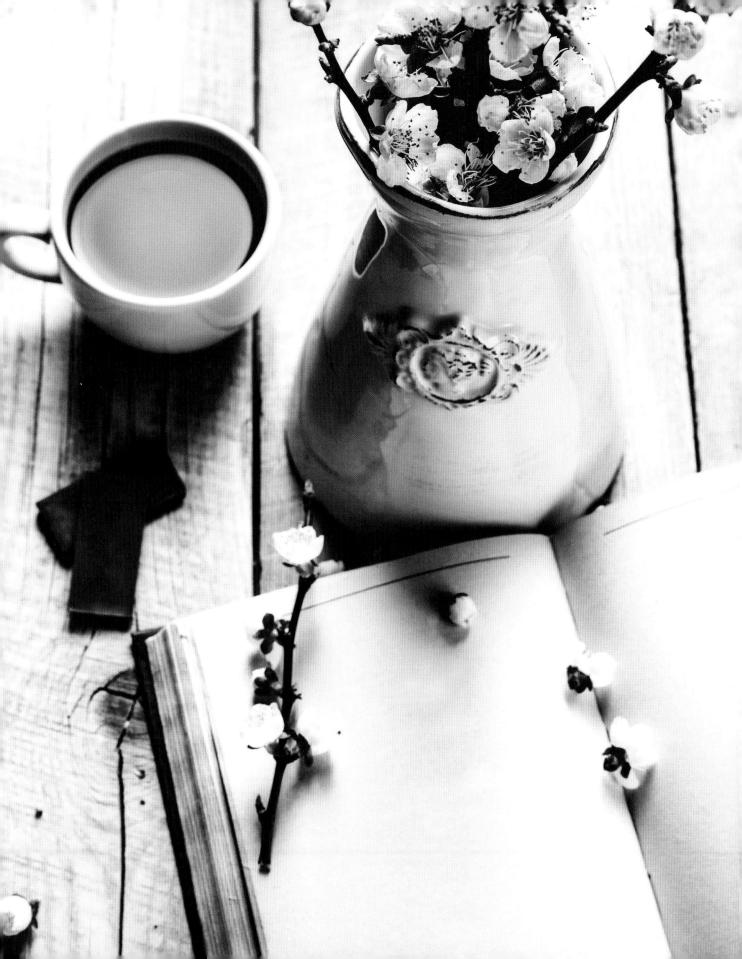

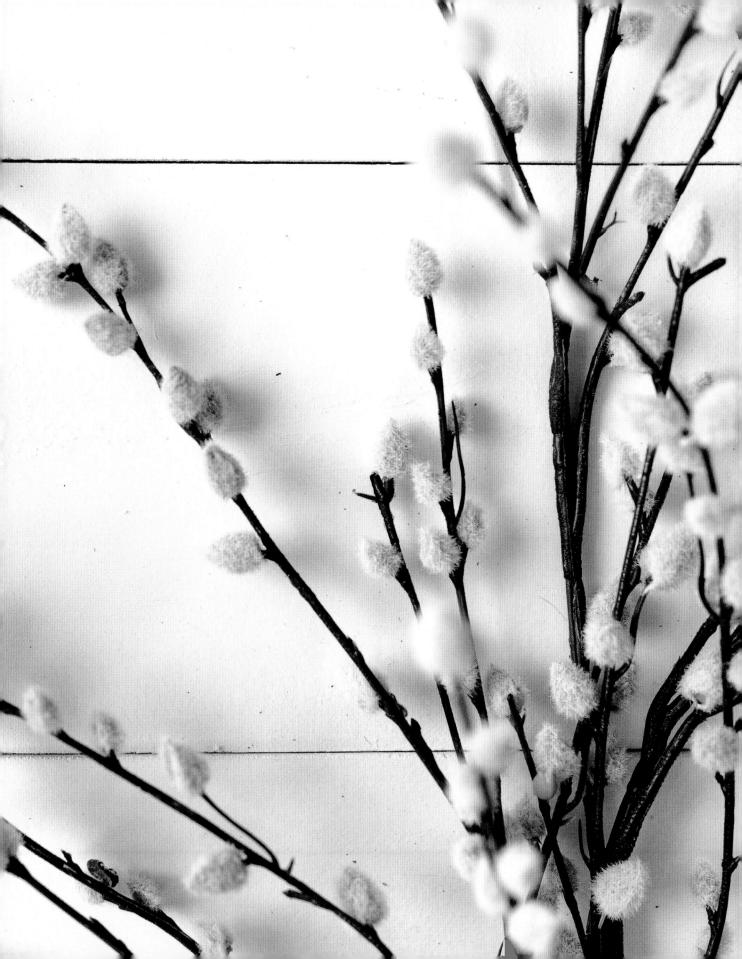

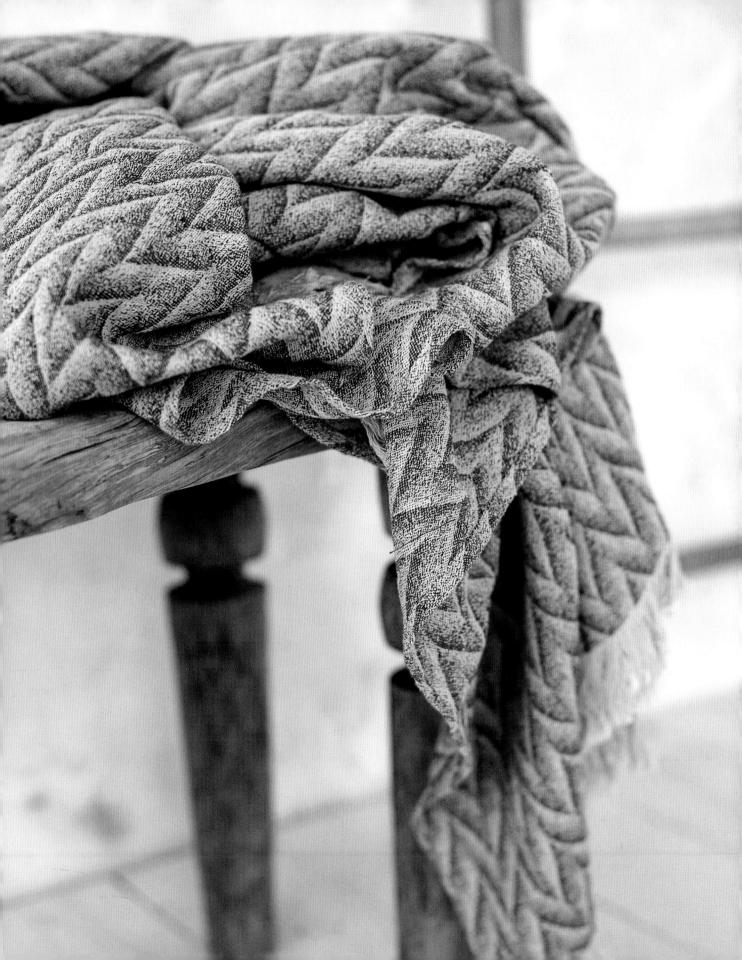

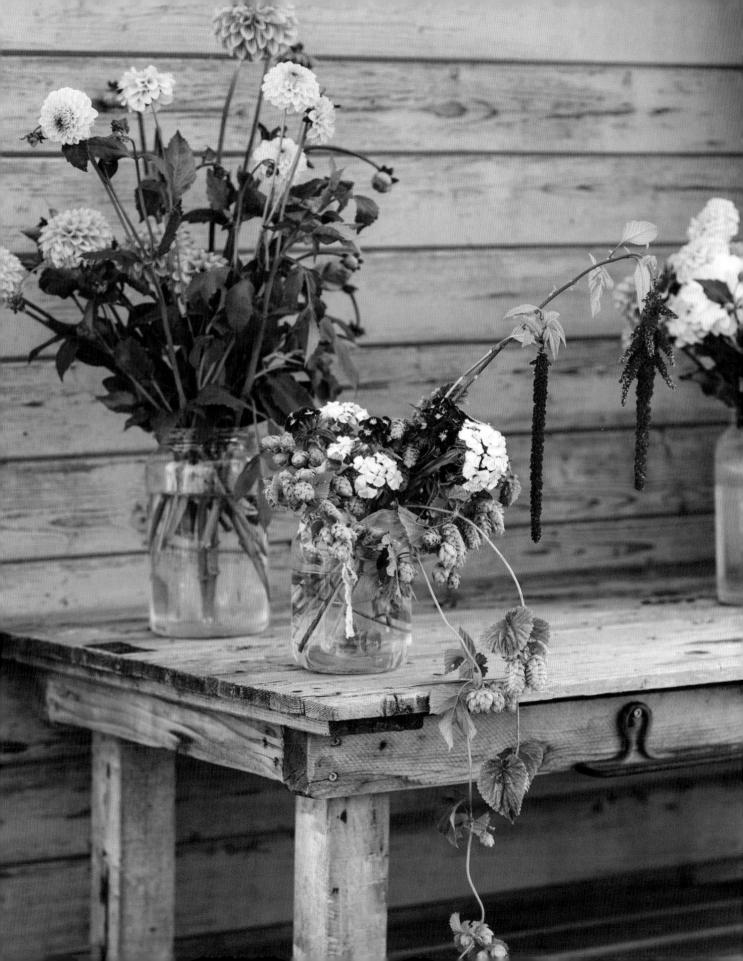